BULLDOG
COLORING BOOK
BELONGS
TO

COPYRIGHT 2019 FRENCH BULLDOG COLORING BOOK, AURTHOR, OR PUBLISHER INFO..

# PAGE 3

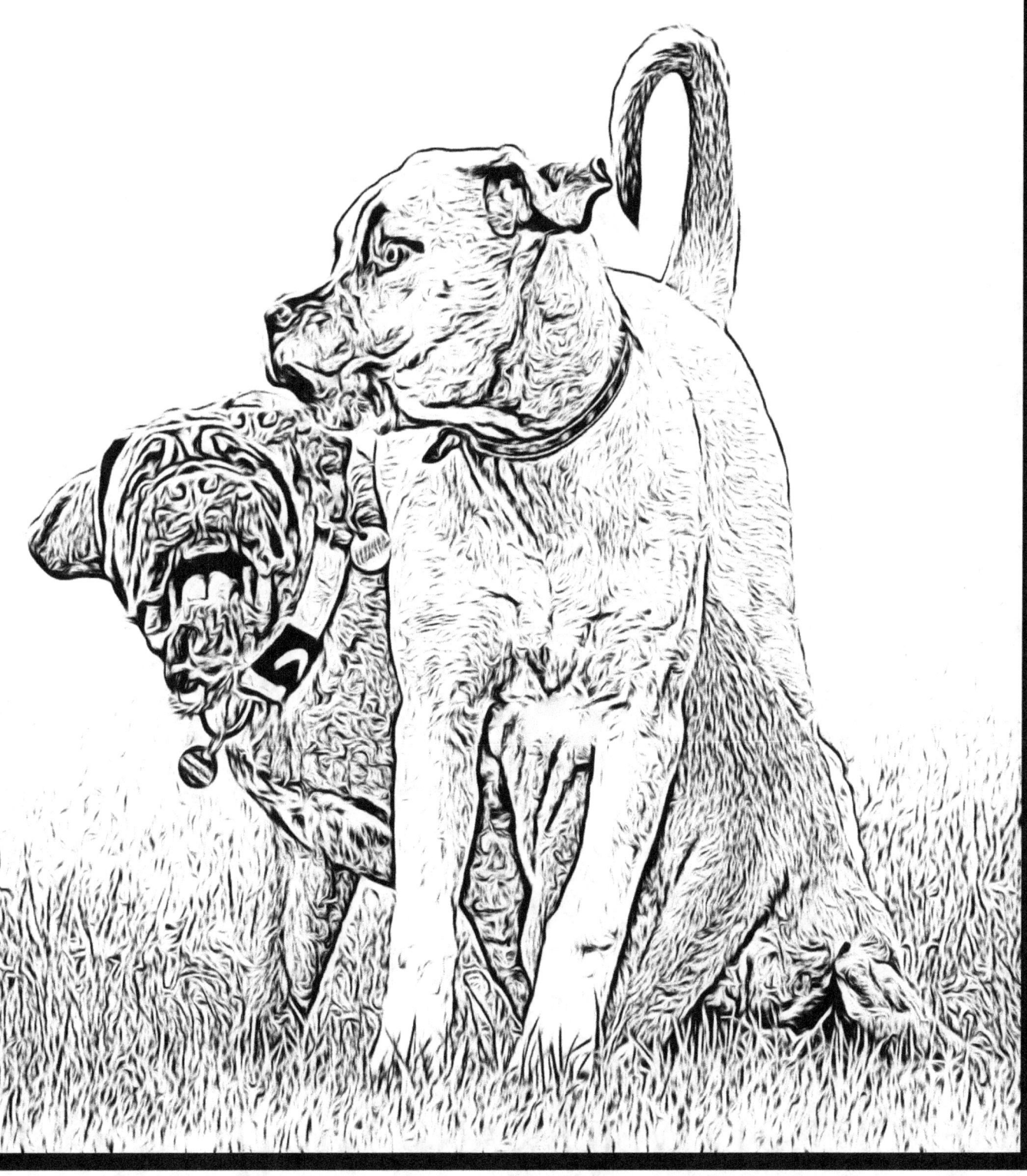

# PAGE 4

FRENCH ROTTWEILER AND THE LITTLE ONE

# PAGE 5

THE FRENCH BULLDOG

# PAGE 7

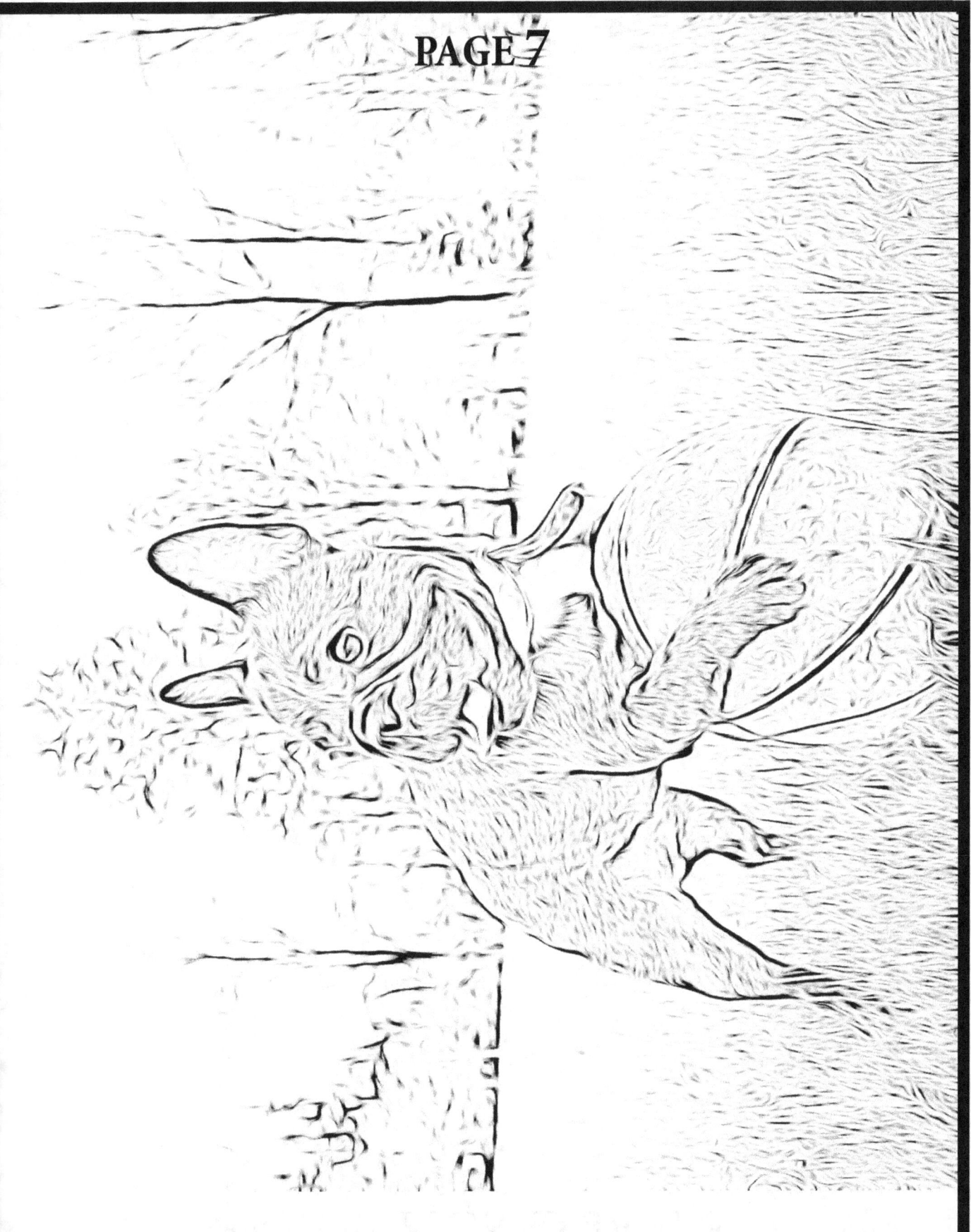

# PAGE 8

# THE RESTING BULLDOG

# RAGE 9

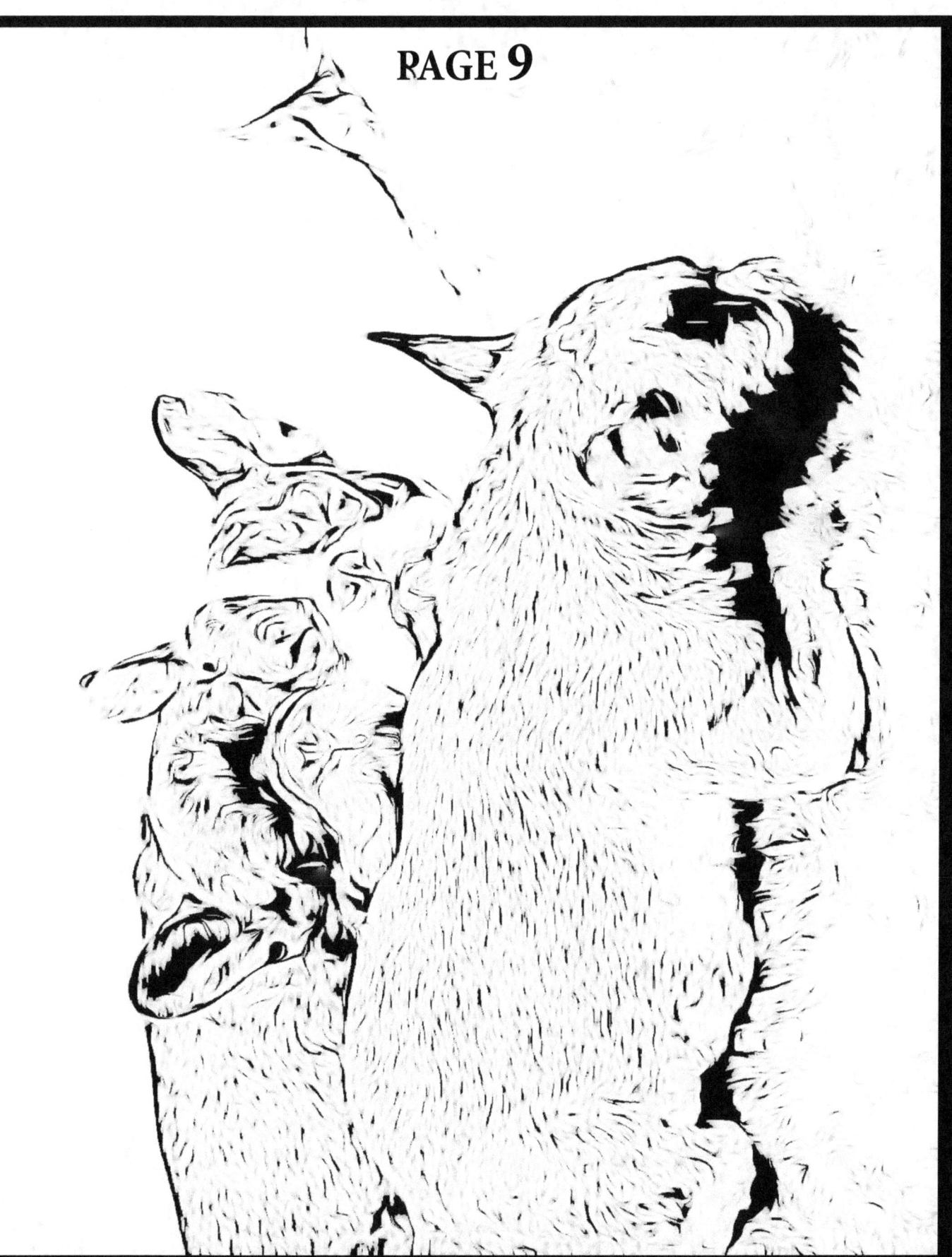

# PAGE 10

# THE FRENCH BULLDOG

# PAGE 11

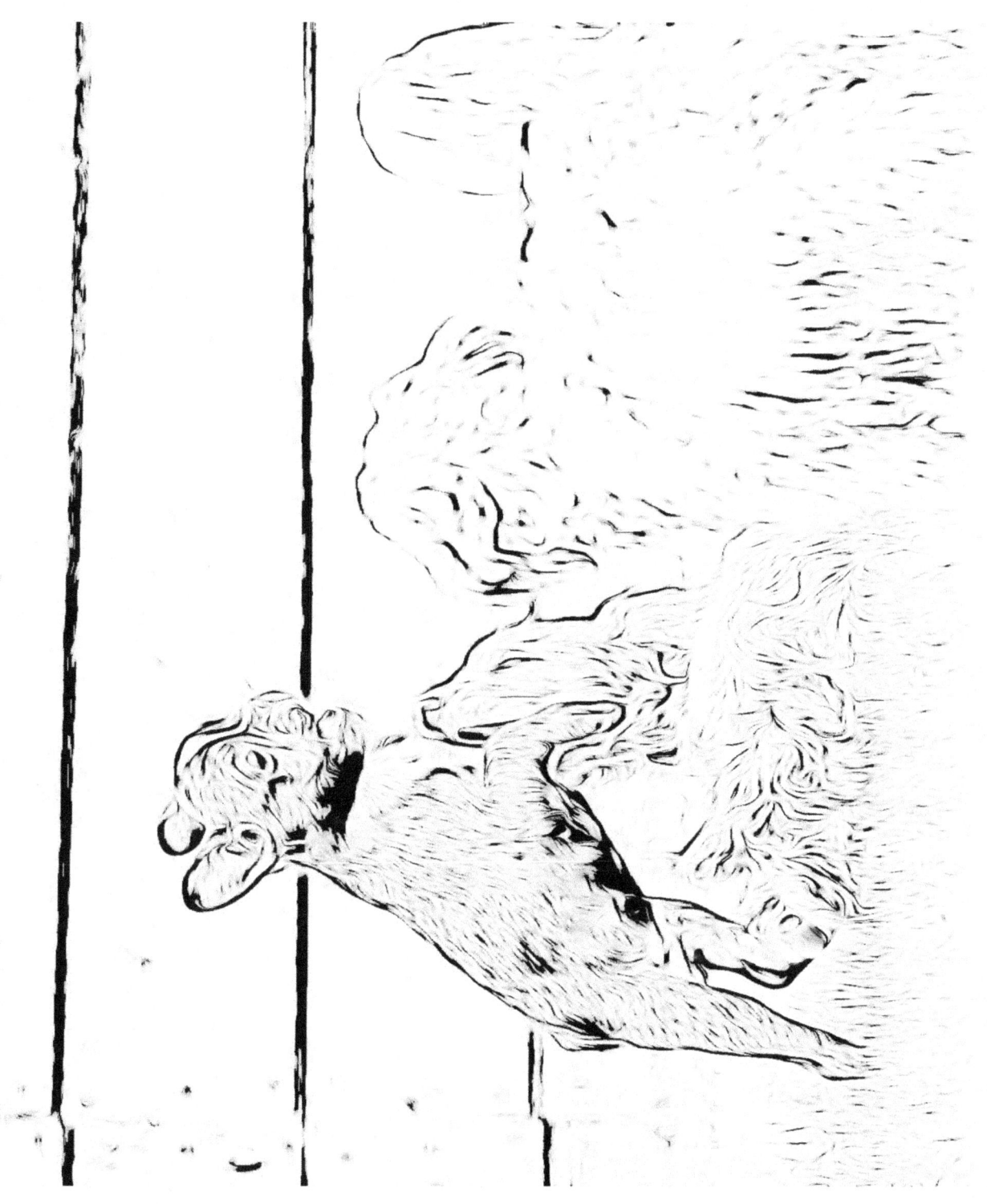

# PAGE 12

# THE GIRL WIHT THE DOG

# PAGE 13

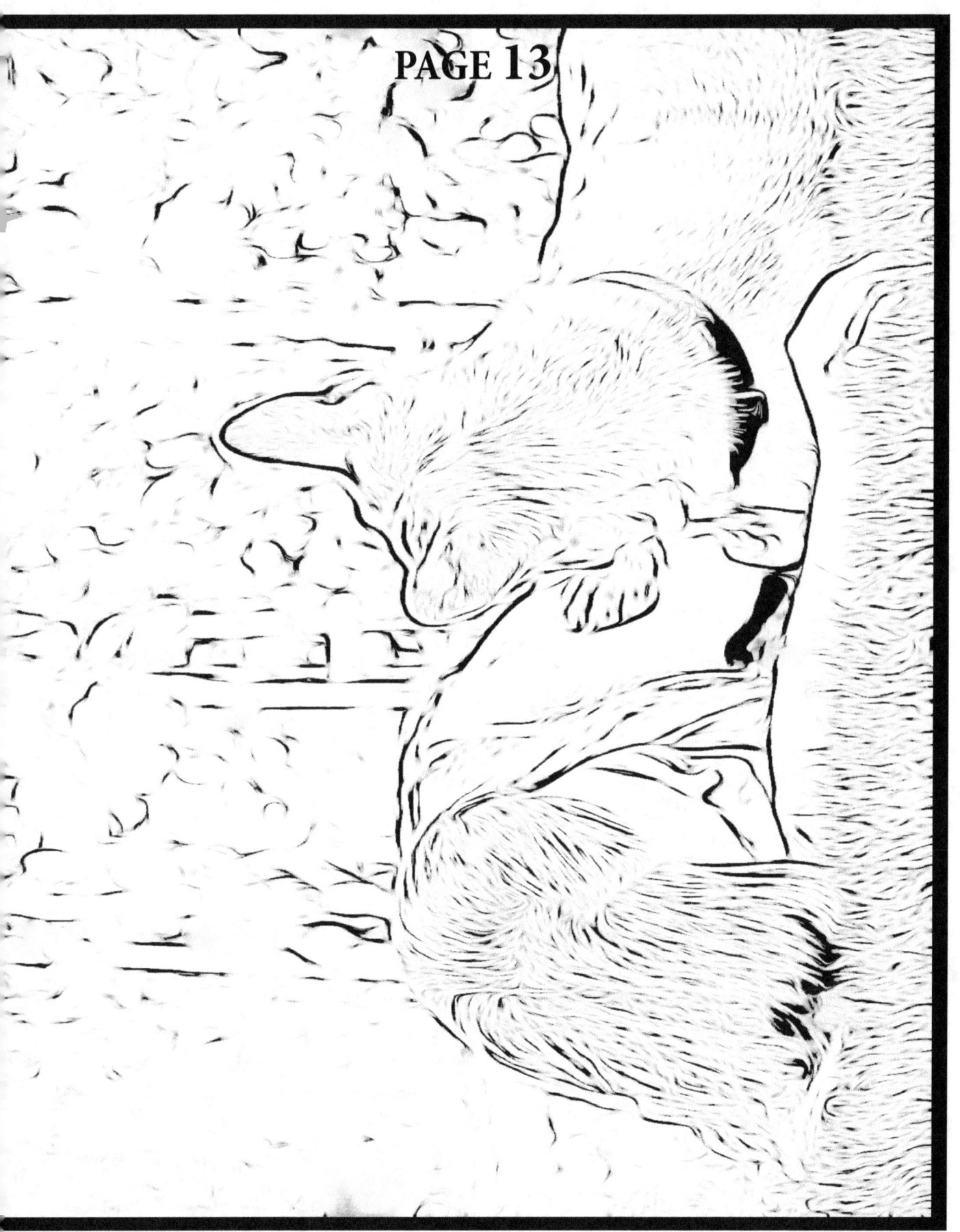

# PAGE 14

FRENCH BULLDON

# PAGE 15

# PAGE 16

# THE GIRL WITH THE BULLDOG

# PAGE 17

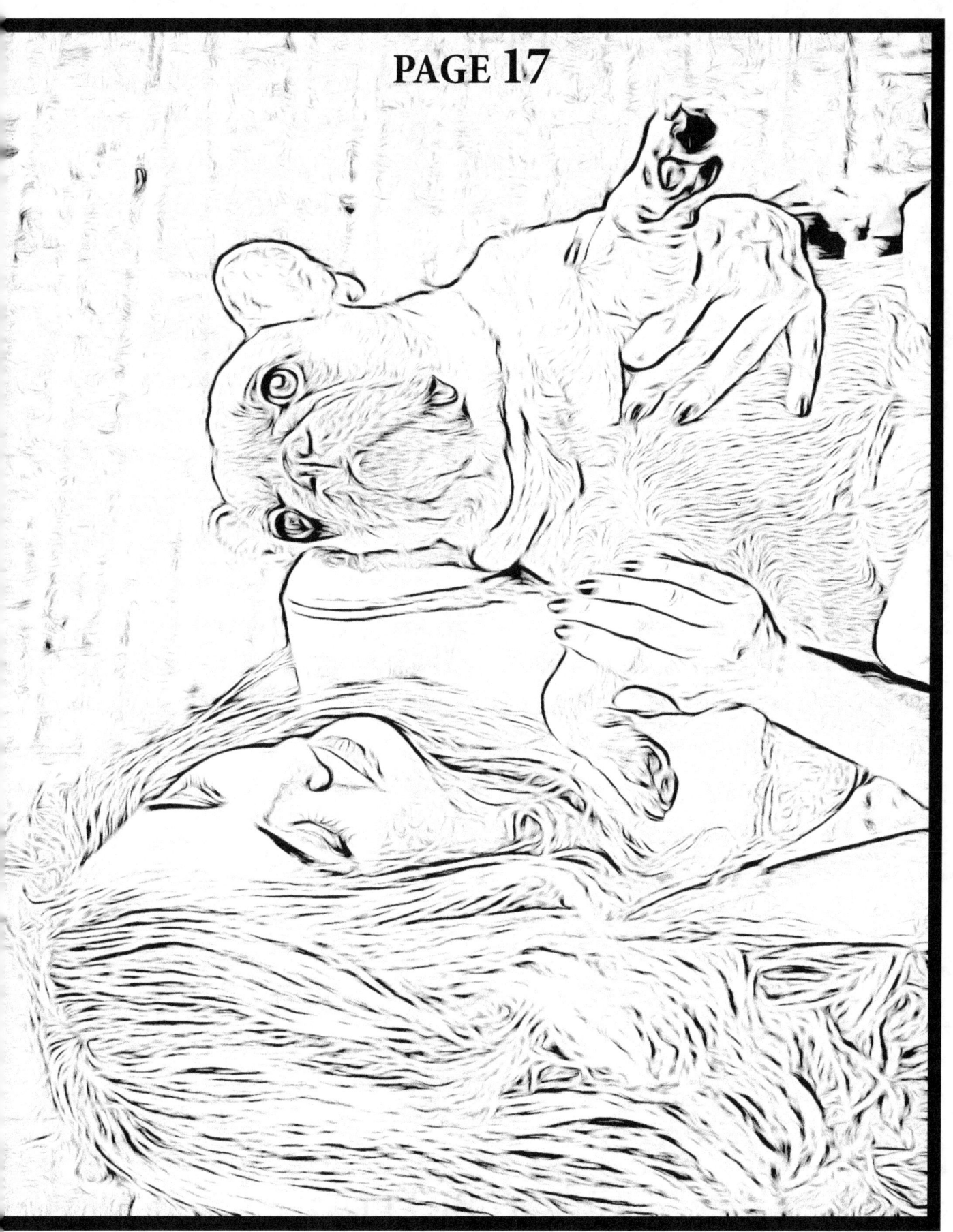

# PAGE 18

FRENCH BULLDOG

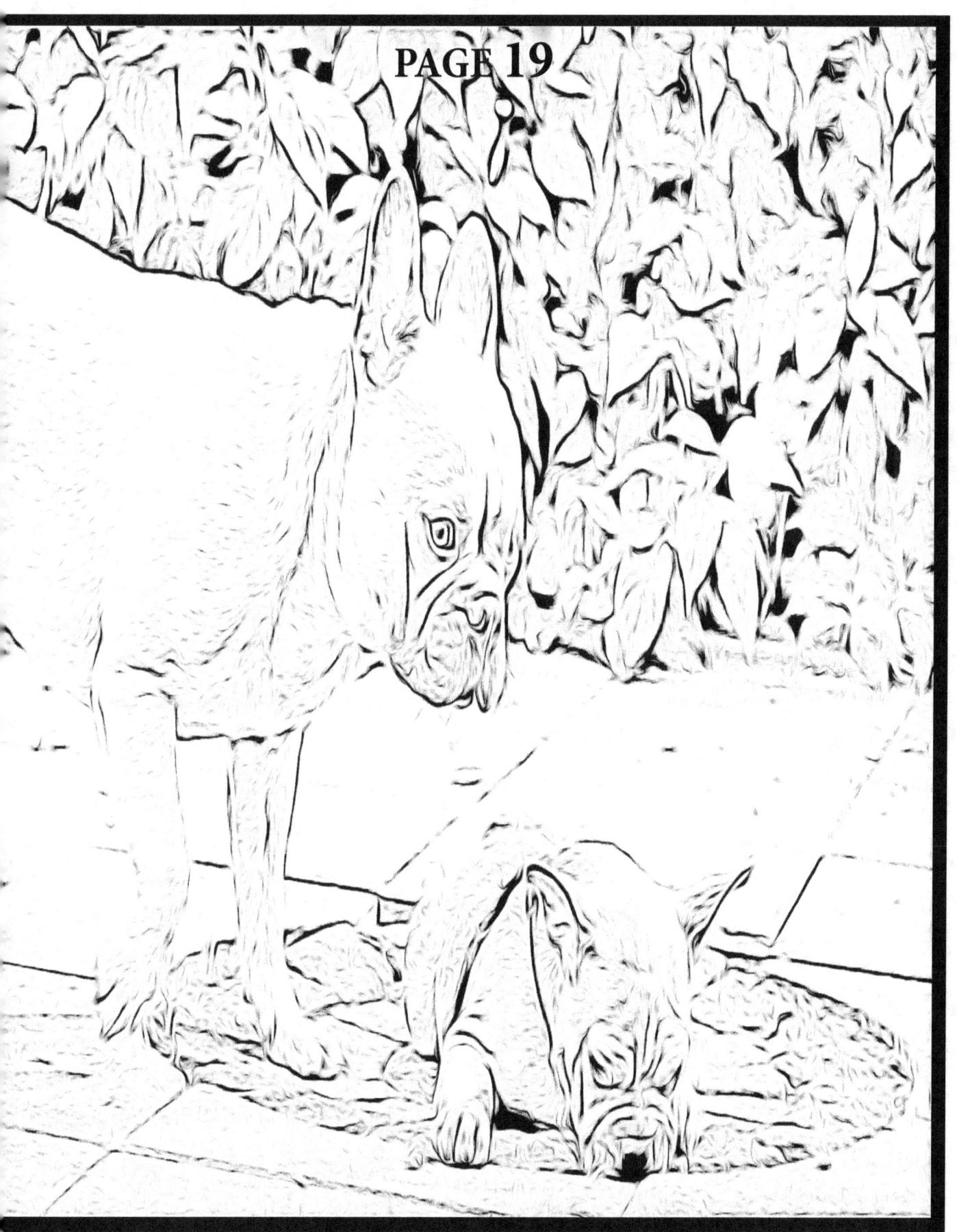
PAGE 19

# PAGE 20

THE ROTTWEILER

# PAGE 21

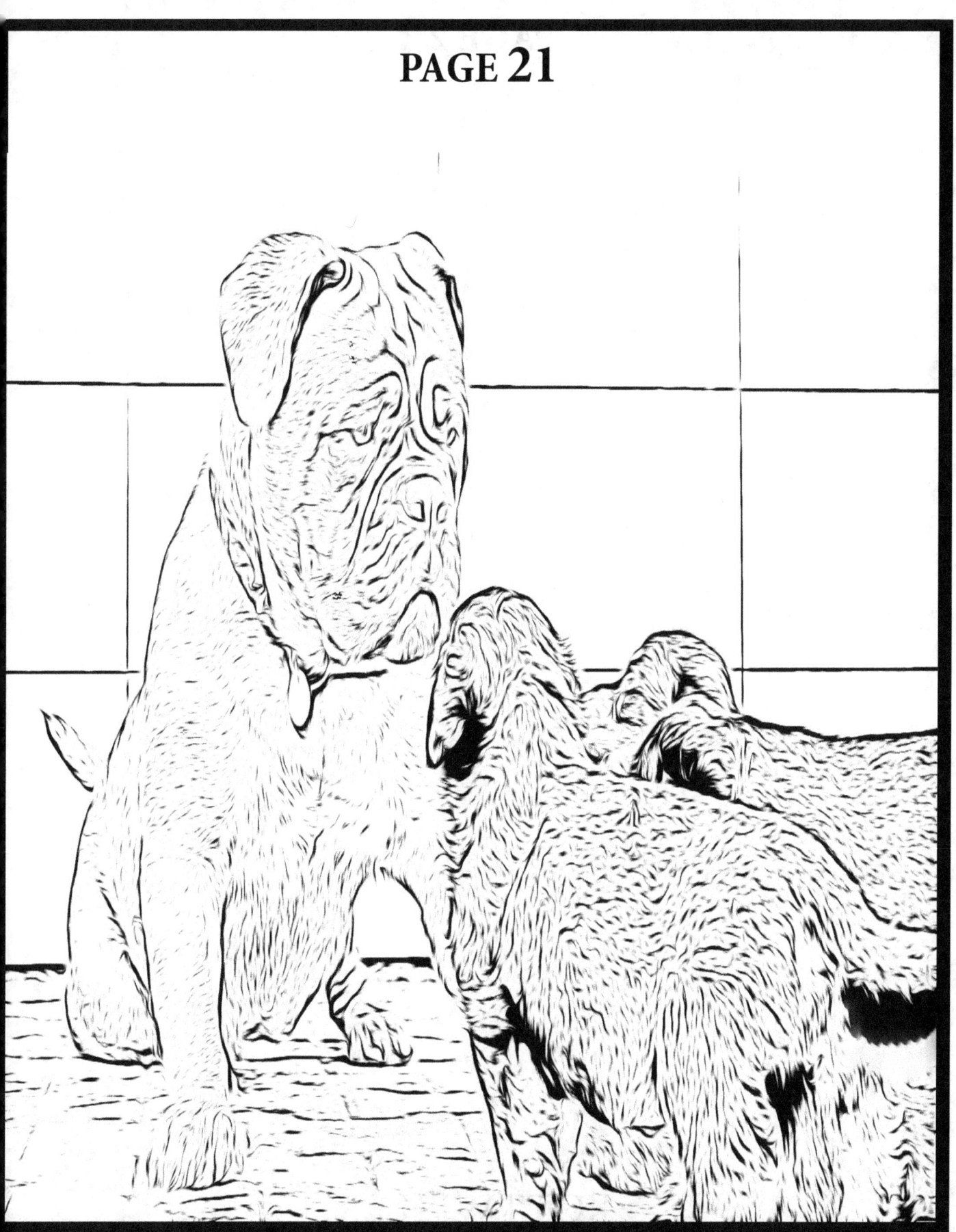

# PAGE 22

ROTTWEILER

# PAGE 23

# PAGE 24

# PLAYING DOG

# PAGE 25

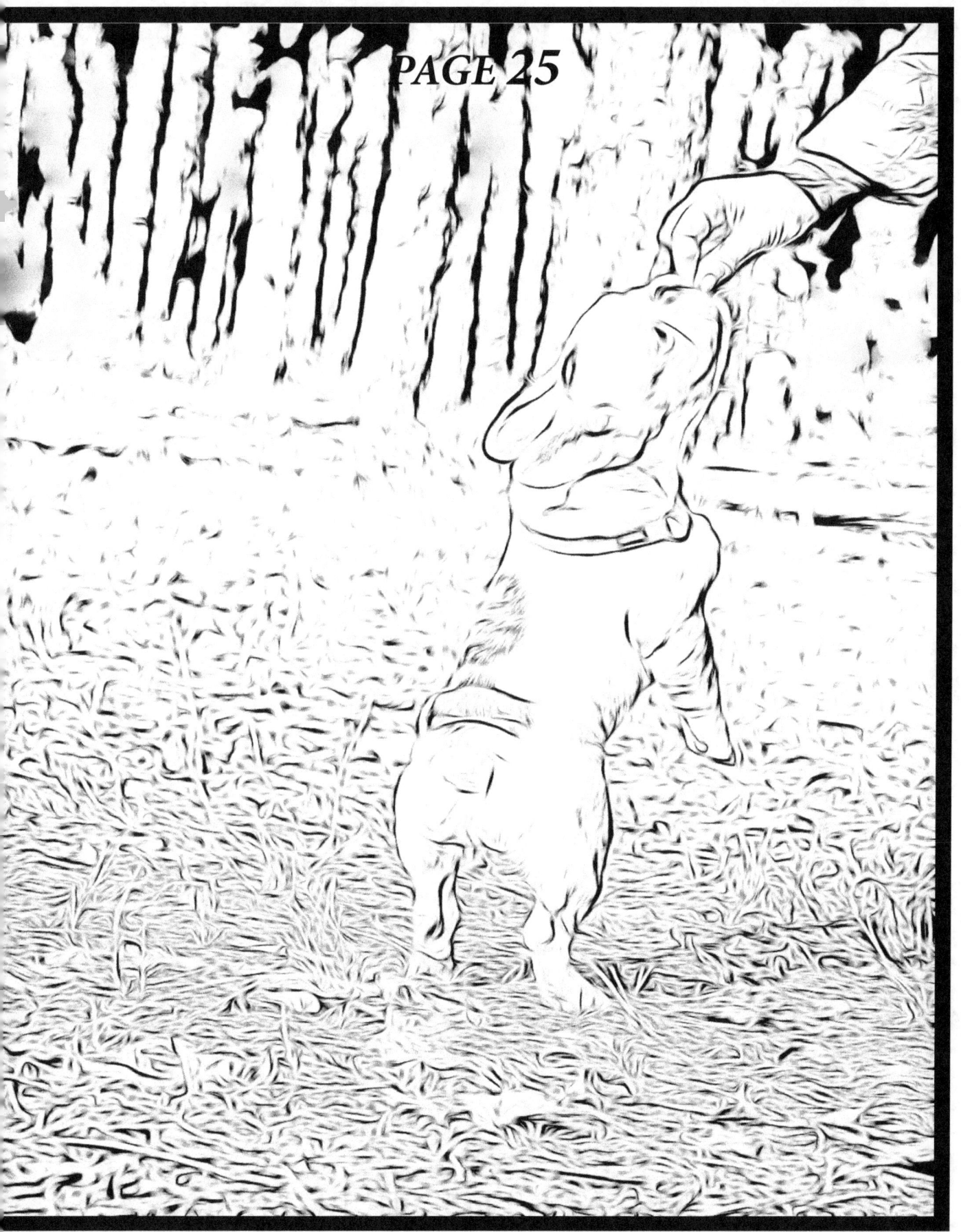

# PAGE 26

# THE MAN WITH THE BULLDOG

# PAGE 27

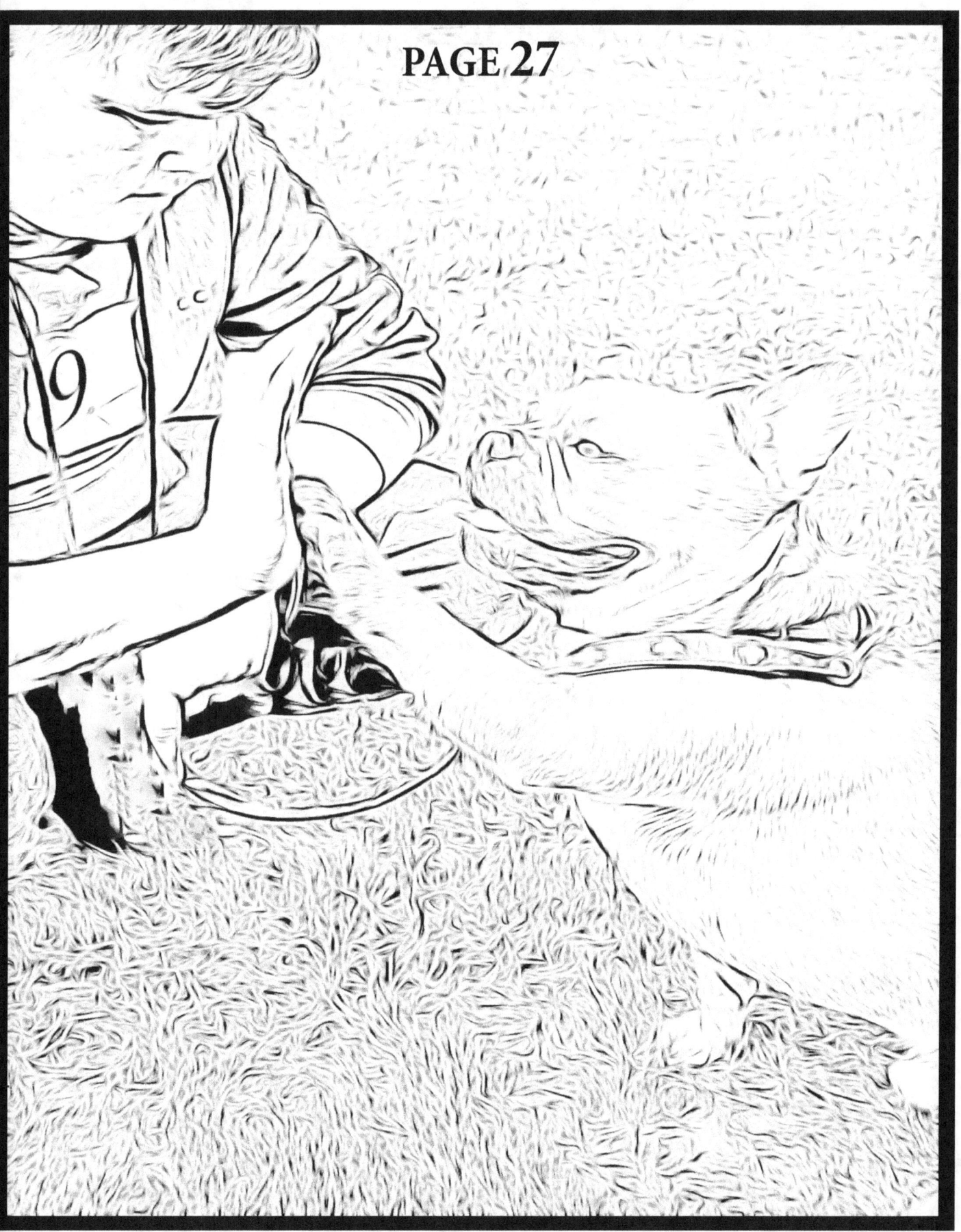

# PAGE 28

# THE LITTLE BULLDOG IN THE BASKET

# PAGE 29

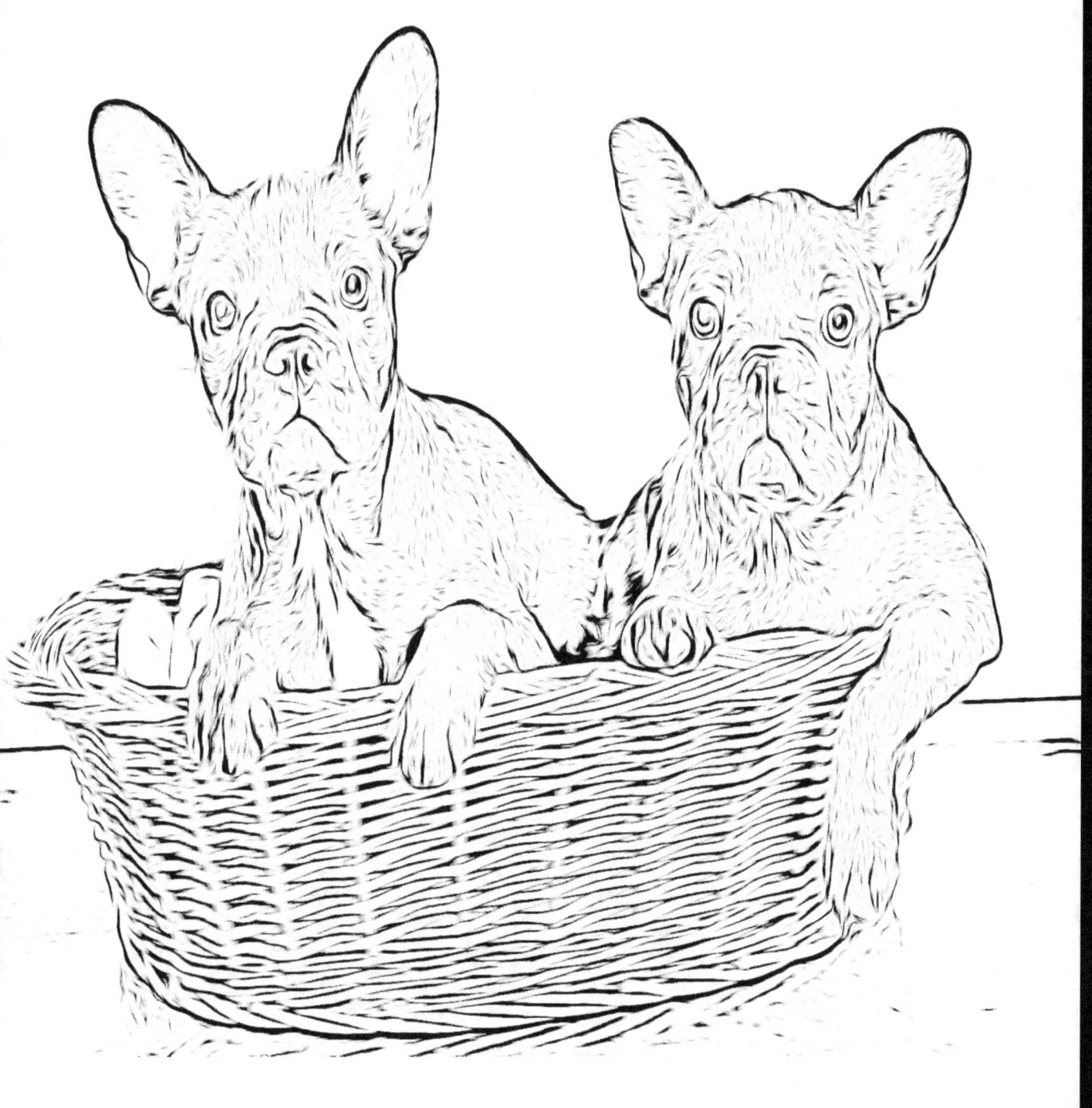

# PAGE 30

# CLAMBING FRENCH BULLDOG

# PAGE 32

ROTTWEILER P0STURE

# PAGE 33

# PAGE 34

BULLDOG

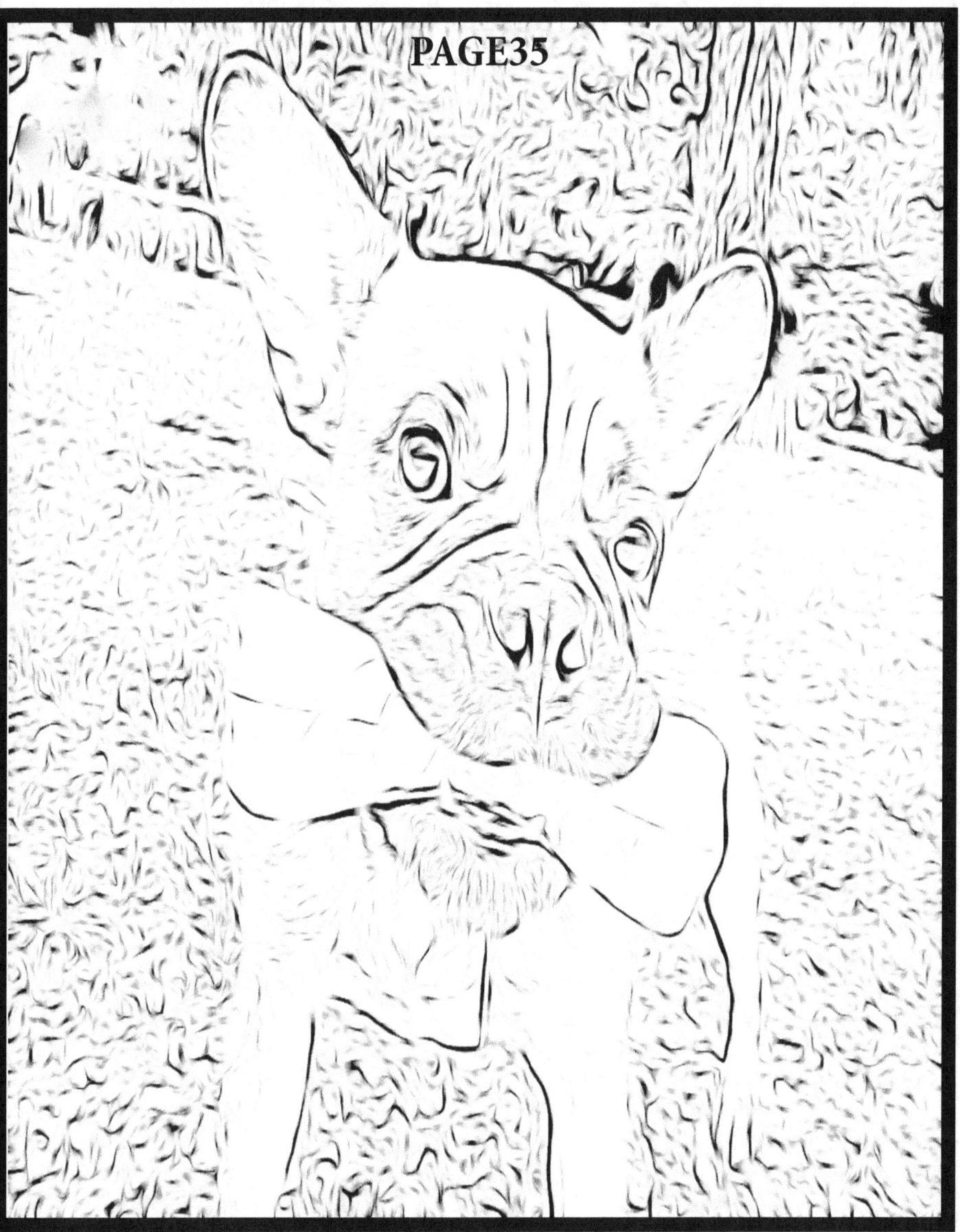

# PAGE 36

ROTTWEILER

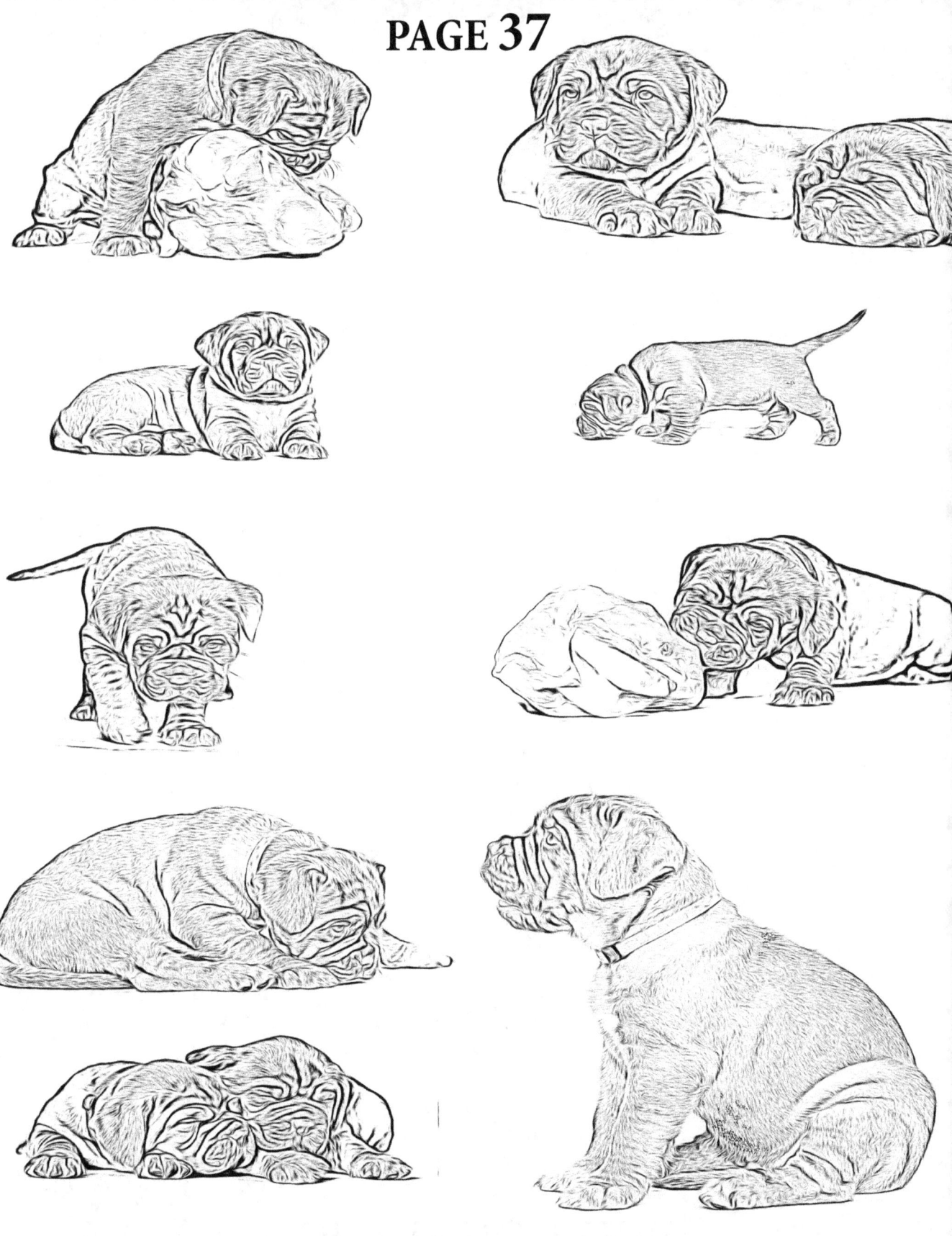

# PAGE 38

BULLDOG MOTION

# PAGE 39

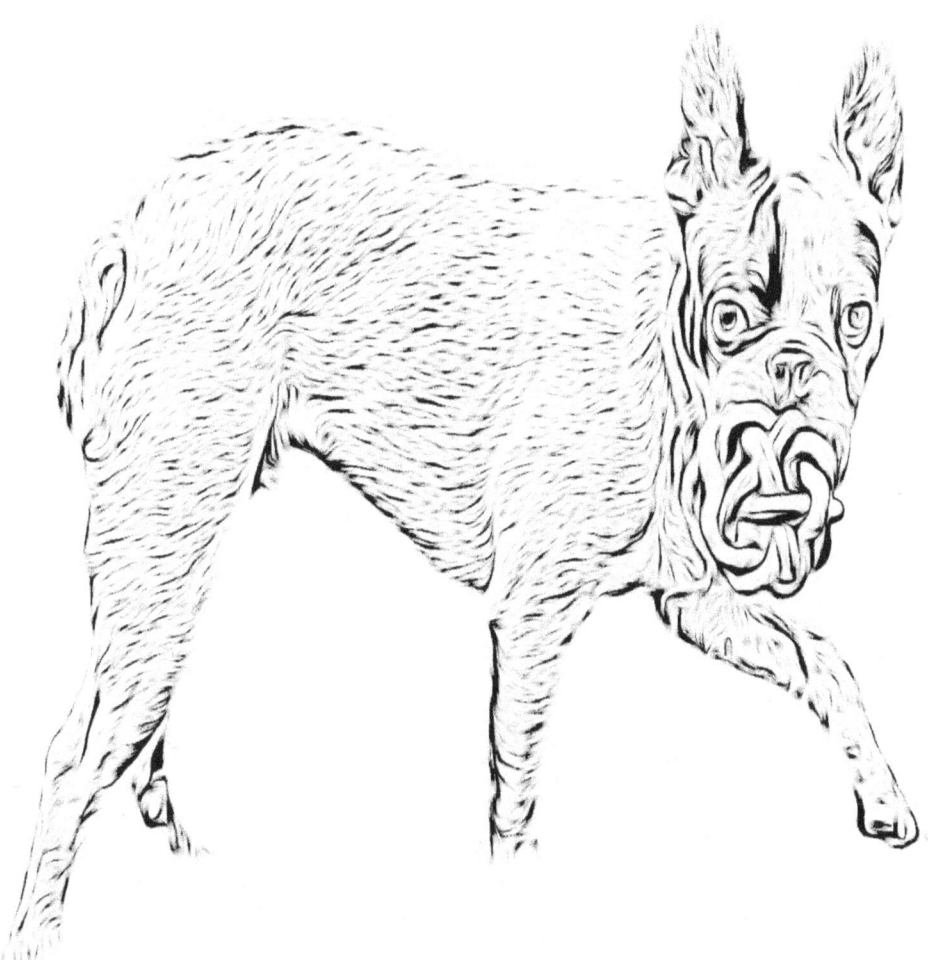

# PAGE 40

# CAPTURE THE BULLDOG

# PAGE 41

# PAGE 42

BULLDOG

# PAGE 43

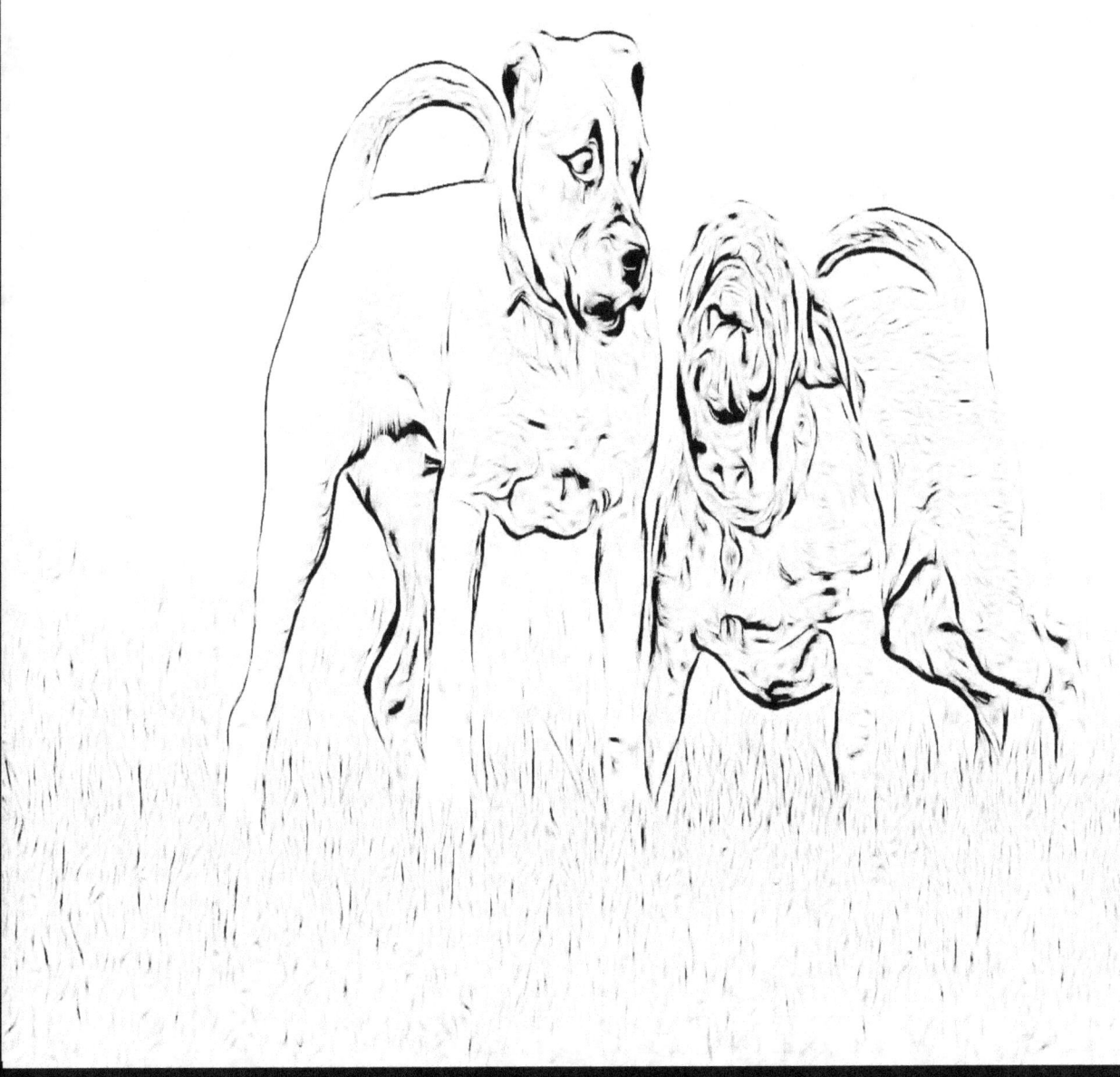

# PAGE 44

# FRENCH BULLDOG

# PAGE 45

# PAGE 46

TWO BULLDOG

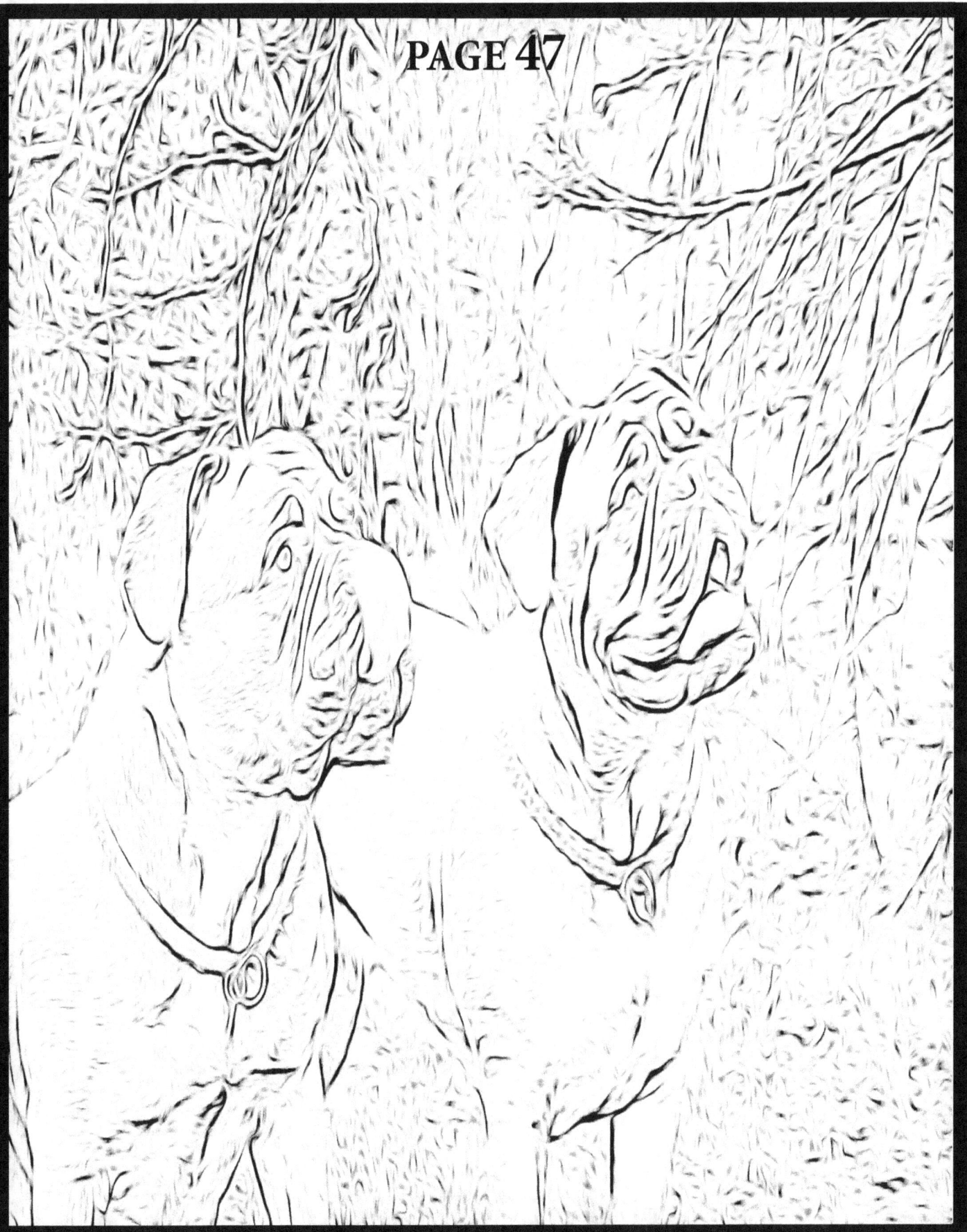

# PAGE 48

## HAPPY BULLDOG

# PAGE 49

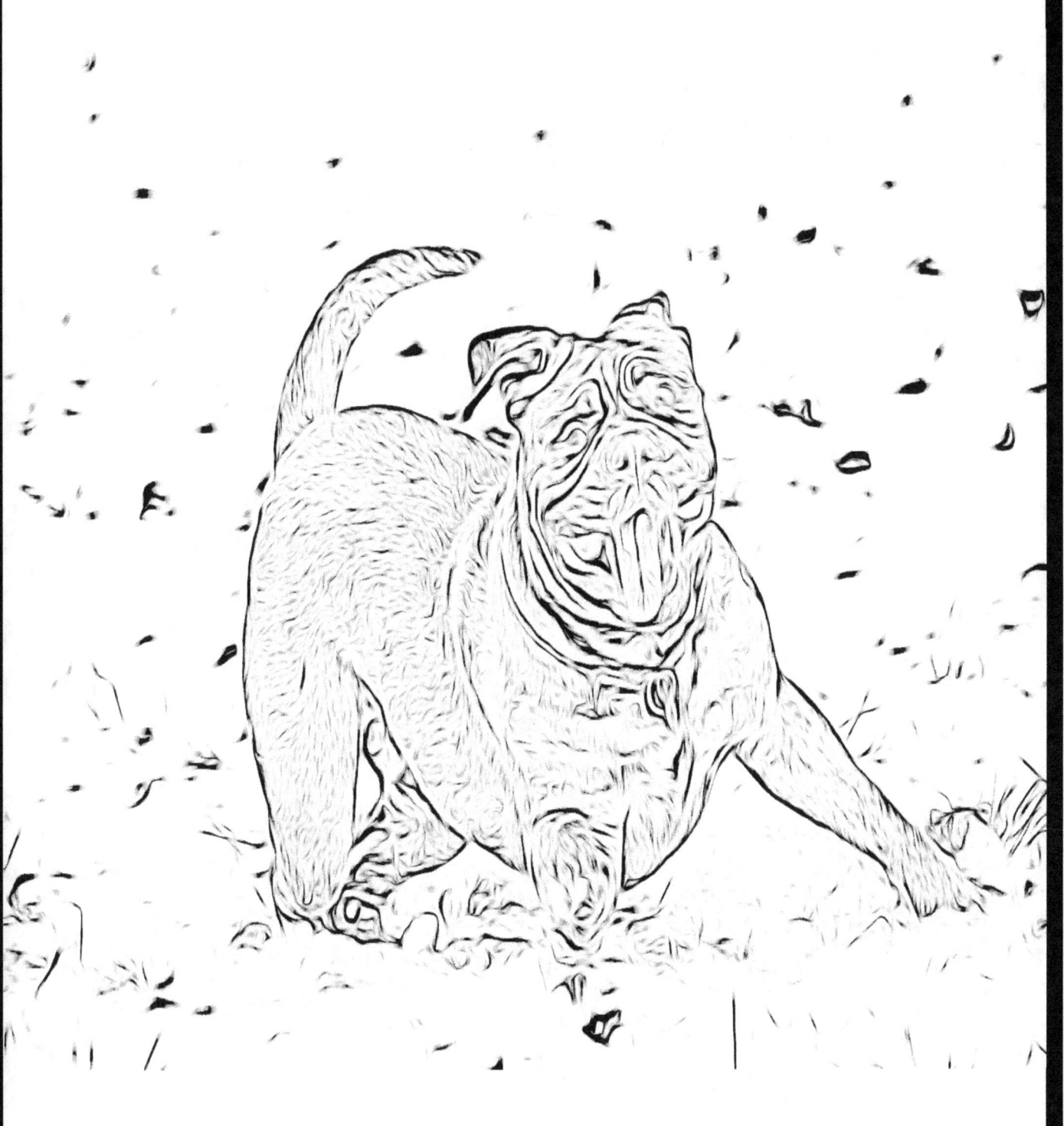

# PAGE 50

# EATING BULLDOG

# PAGE 51

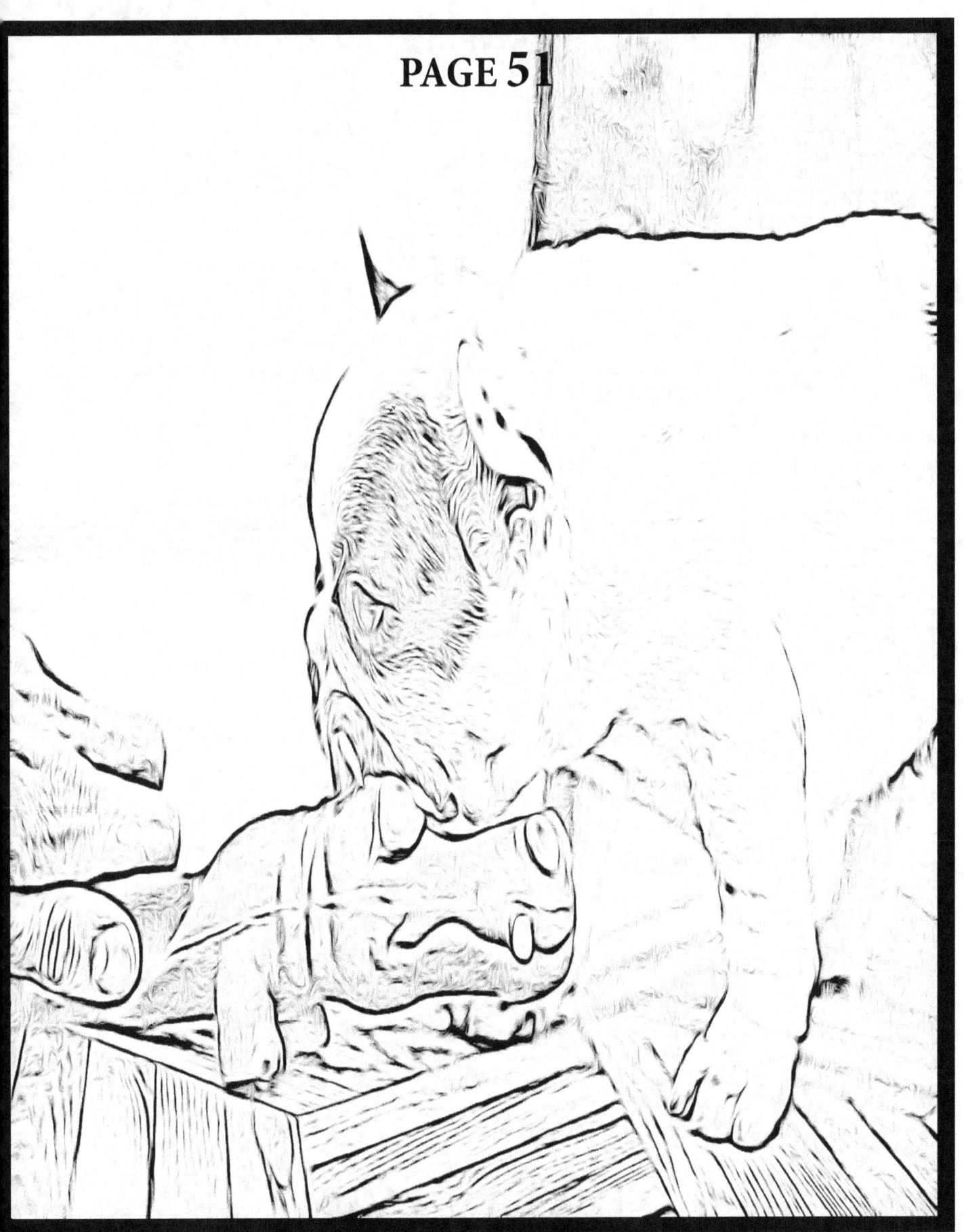

# PAGE 52
# BULLDOG COLORING BOOK FOR KIDS

THE LAST PAGE

www.ingramcontent.com/pod-product-compliance
Lightning Source LLC
Chambersburg PA
CBHW080908220526
45466CB00011BA/3505